In Dreams

In Dreams

DIANE MEUR

TRANSLATED BY TERESA LAVENDER FAGAN

WITH COLLAGES BY SUNANDINI BANERJEE

Seagull
BOOKS

LONDON NEW YORK CALCUTTA

Seagull Books, 2012

Original text © Diane Meur, 2011

Translation © Teresa Lavender Fagan, 2012

Digital collages © Sunandini Banerjee, 2012

ISBN 978 0 8574 2 029 9

British Library Cataloguing-in-Publication Data

A catalogue record for this book
is available from the British Library

Designed by Sunandini Banerjee, Seagull Books
Printed and Bound by Hyam Enterprises, Calcutta, India

This book contains my dreams from 2008–10—a time
of global crisis, which happened to coincide
with a personal one.

They are not my life, they are not my writing, they are
simply my dreams, those I remembered and noted down:
all of them, and every part of them,
without censoring or omissions.

My thanks to Teresa Fagan for translating them into
English and thus making them fit to be published.
I wouldn't have had them published
in their original language.

And my thanks also to Sunandini Banerjee,
who turned them into art.

Diane Meur

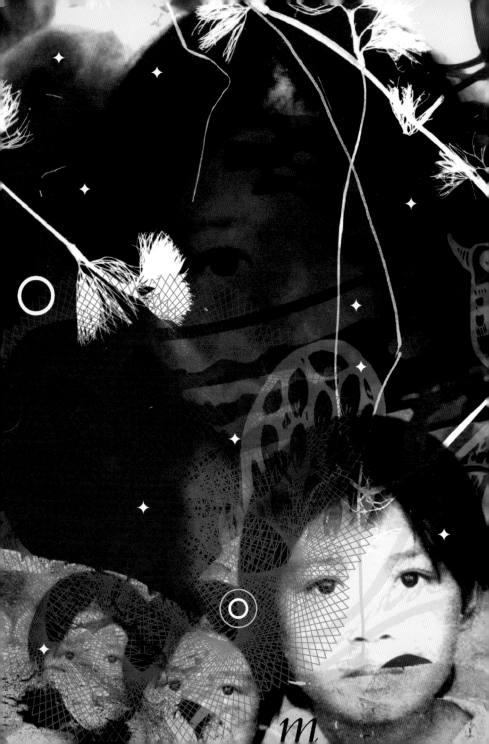

Paris, 30 March 2008

I'm in Monbos, but during All Saints' Day, which is a first for me. I discover a custom: those who have lost a family member during the year shut themselves up in a mausoleum and stand there all night long. Behind the bars their faces are fixed and in mourning. I don't want to do it (claustrophobia). I look at them, terrified. There they are, standing, crammed together like deportees.

In Dreams

Montreal, 30 April 2008
I am naked, alone (for the moment) in a sort of sun-drenched lagoon. I notice that a large bramble branch is coming out of my body, the diameter of a man's organ. But it isn't hurting me, obviously there are no thorns on the part inside me. I don't know why, I first have to cut it down to a reasonable size, about 20 centimetres, before I can take it out. Which I do—I can't stay like that, can I? At that moment the others come back on a boat, laughing and singing. I'm upset that they might have seen me pulling the branch out, so, to divert their attention, I take off, still naked, swimming madly out into the water.

Ventspils, 26 July 2008
I was visiting J's family. His wife was an old Mexican woman, practically mute, absent, always busy in the kitchen, who greeted me gruffly but probably no more so than she would have anyone else. I tried jabbering a few words to her in Spanish. Curiously, their children spoke French but with a strong Québécois accent. I tried to have a conversation with the daughter, near a window, by pointing out the sea which wasn't far away.

I asked her if the waves reached the house when there was a storm. Then J said something rude to his father and I told him, 'You shouldn't speak to your father that way.' He took it badly and became very aggressive. He frightened me a bit, he was beefy, his head shaved.

I wandered round the house, which was empty, disturbing, with irregularly shaped rooms and walls painted yellow or bright orange. I tried to find the family but they seemed to be constantly going into other rooms, I lost them. Finally, in a (game) room without windows there were four or five friends of J, all with shaved heads, sinister-looking. I turned towards the door because someone was coming in. At first I thought it was one of the boys, but it was a short, bald man, which explained why I was mistaken. His face was appalling—where his right eye should have been there was only smooth skin, without a hole or a scar. He came up to me and snarled that there was no point looking for J because he had left. While telling me that he groped me lecherously, I tried to move away, I called out for J, I now understood that I was alone in the house with this one-eyed man who was going to rape me.

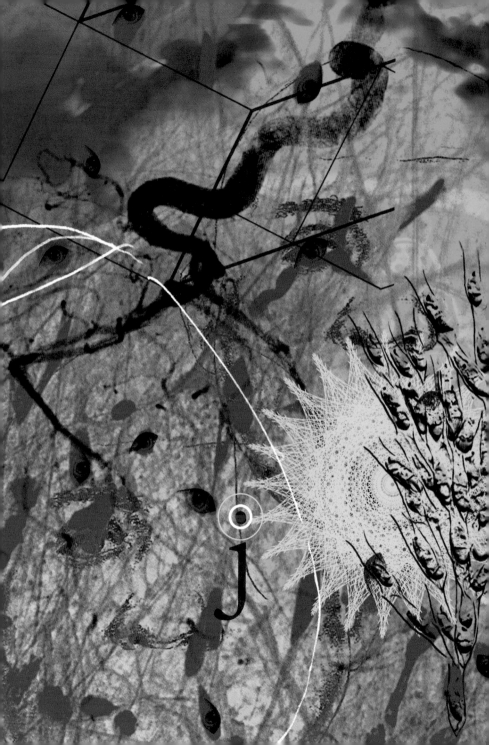

Paris, 7 August 2008

Refreshing. I'm in Brussels and I go out for a run along Vanderkindere Street and Bel-Air Avenue. I realize that I'm running fast and effortlessly, it's pure pleasure. I discover places I didn't know, in particular a winding street with a large store selling sailing supplies. There are flags and multicoloured buoys in all the windows, they are pretty and cheerful, and I promise myself I'll bring J here one day. Then I breeze into unkempt gardens, there are trees, the sea, I feel wonderful. A small problem: I parked the jeep in a sand-filled garage and it got stuck, I'll have to come back later . . .

Back on campus where my roommates are waiting for me, there is great excitement—a delegation of extra-terrestrials has just arrived from the planet Saaremaana. One of them is a young man, radiantly young and svelte, handsome in spite of his somewhat strange extraterrestrial features. We like one another, and we begin to really want to make love. I consider taking him to the garage where the jeep is still sitting. He tells me about the Holland back home, I'm surprised there's also a country by that name on his planet. He then says

something to me in perfect Dutch and I'm not sur-
prised any more, since the names of countries come
from the local languages and Dutch is also spoken
where he comes from.

We leave and head for the garage, consumed with de-
sire. I look for a drugstore on the way because I don't
want to get pregnant by an extraterrestrial, it would be
far too complicated. I also tell myself that it's not a good
idea to get romantically involved with someone who
lives so far away, I will probably get hurt, but it is clear
that this isn't going to hold me back.

In another part of the dream (before or afterwards), I
throw my arms round SN and cover his face with kisses,
including his mouth, accidentally; he is very happy
about that.

Paris, 4 November 2008

Pushed, drawn in by a group of revellers, academics and
publishers, I have just enough time to throw on my old
red dress (the one I wore at Laurent's fiftieth birthday
party). We go to various places and I find myself at
a private party in the very large apartment of Alain

Dutronc (*sic*). He doesn't know what I'm doing there, and neither do I. (Van Gogh.) We begin chatting flirtatiously, and rather quickly, start kissing. A woman comes in, she could be the housekeeper or his wife's children's babysitter. He pushes me under the desk to hide me. She stands right behind him—I can see the edge of her skirt and her stockings—I find the situation humiliating, especially since she must certainly see me, at least my hair, and must imagine even worse than what we were actually doing. I stand up and, to my great surprise, the lady speaks to me respectfully. Bizarrely, I feel completely at home now and begin to explain to them, finally, who I am and how I landed there.

In Dreams

Paris, 7 March 2009

I'm in a microstate, something like Liechtenstein, a tiny banana republic, ultramilitaristic. The international context is tense. Something upsetting: two nuclear warheads ready to be launched stand on the edge of the lake like monumental statues, Sunday strollers passing peacefully below them.

And then the clownish general who leads this country ignites them, I see them slowly rise up into the atmosphere and disappear, I can't tell where (towards which country). In the generalized stupor, I want to assure myself that I haven't dreamt it and, with an abrupt change of scale, I put my finger into the place that until then was holding the warheads. My finger fits in perfectly, the space is empty, so I wasn't dreaming.

Paris, 2 April 2009

Dreamt that not our real father (although there had been some doubt) but the man my mother was living with when my sister was born was a certain Mehdi Dama, researcher, historian or sociologist from a very arid country, Libya, perhaps. (It was while I was in high

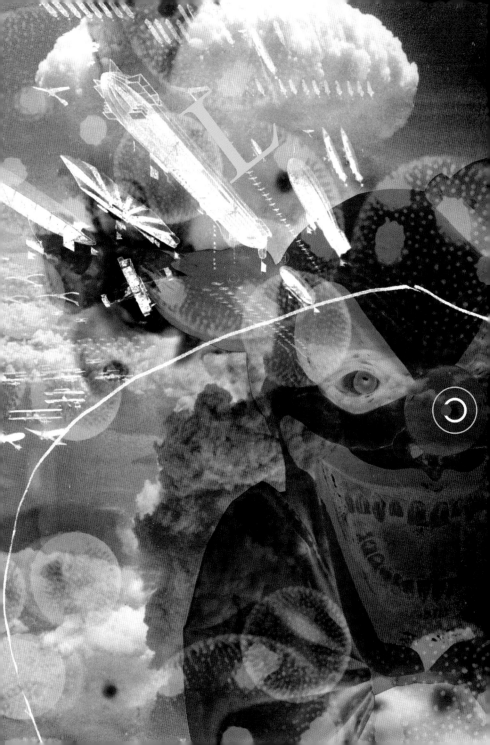

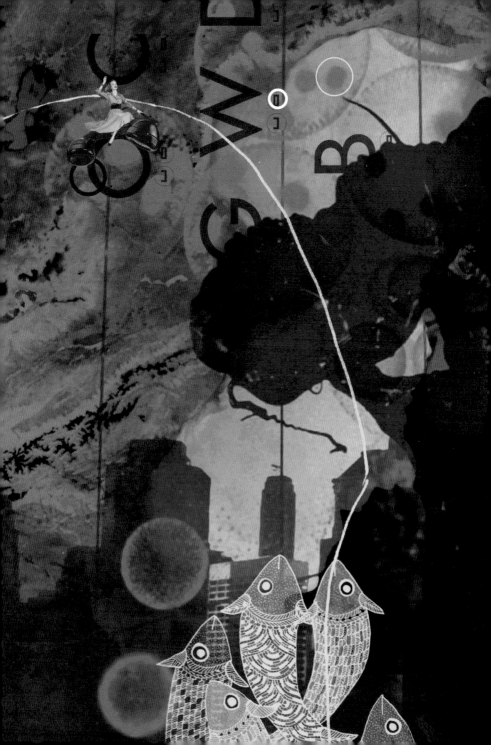

school, while writing a newspaper story for a German class that I learnt how to spell 'Libya' and 'Syria', which is probably how I got Dama[scus]. And the *Dame* of the lake, though not very arid by definition. I listened to that record at Prangeleux when I was a little girl.) I tried to get to know him at a cocktail party. He gave me a piece of paper with scribbling on it, something like a list of errands or notes that you take while talking to someone on the telephone, which dated from that time and documented the facts. Unfortunately, while I was talking to my mother about it later, I put it on the table and, while cleaning up, she threw it away, on purpose, to destroy the evidence. In the meantime, moreover, I was taken to task by my father who had told me, 'A father and a mother, that doesn't make Belgium yet.' A statement that, in that context, was completely enlightening.

Later, while travelling, I noticed (from the middle of a country field) the towers of Manhattan in the distance, emerging from a yellow industrial cloud.

Paris, 15 June 2009

I'm walking round a holy city, perhaps Jerusalem. The entire city is but a huge, rocky hill, pocked with holes and valleys, bathed in a brownish, funereal light. (Les Trois Croix.) There are also ski lifts but they add no cheer.

Paris, 5 July 2009

On the rue du Pressoir, at night, I encounter a man, a stranger, peeling a large, grilled scorpion with his fingers (as you would a shrimp). He offers me a piece and I don't dare refuse, but I really don't want the bit he offers me, which is covered with brown hair. I explain to the man that it isn't cultural but physiological, it's like the skin of a peach, I can't help it. He then gives me the whole thing so I can help myself. The piece I pull off is much bigger than I wanted but I eat it. It's not so bad.

Paris, 18 July 2009

Last night I dreamt that Venice was actually inside Paris. Somewhere on the rue de Turenne, we passed a porch, entered a courtyard where there was a large, very wide staircase. Below, we were in Venice. I was surprised; in

Venice the lagoon is all round you! But there was a simple explanation, which I've forgotten. It was wonderful to think that on any given day, on a whim, I could go down the stairs and take a stroll round Venice.

Paris, 7 December 2009

I'm in bed with V and his boyfriend, who in my dream is a slightly aggressive blond, misogynous, perhaps. An atmosphere of triple rivalry and camaraderie. The bed is soaked, I need to wipe it with towels before continuing. V wants to go again, which bothers his boyfriend a bit. 'Oh, go ahead', I say, 'don't worry'. I haven't made love for six months.

I'm having lunch with some publishers and various other people, in the upper deck of a double-decker train car. SN puts me on his lap in a clearly sexual position, but actually it's quite innocent, and no one reacts. A waitress takes me aside: 'Is it true that your group is secretly celebrating a marriage?' 'Not at all,' I laugh, 'it's only a bunch of people in publishing having lunch.'

In the meantime, the train has travelled a great distance and stops at the first station after the Iron Curtain. It's a ski town in Croatia, there's a lot of snow, completely

crazy futuristic architecture. 'This reminds me of the 1970s,' I say to someone. We are taken to the train guard's office, expecting trouble. How and when am I going to get home?

Paris, 8 December 2009

I'm invited to a debate in Brussels with several Iranian sociologists, one of whom is connected to VP who warmly recommended his book to me. I'm embarrassed because I haven't read it, in fact, I haven't prepared anything at all what am I going to say, apart from what I know thanks to Etemadzadeh's *Zardosht*? In Brussels, near avenue Louise, I get angry at an organizer who is trying to convince us to take two buses to the place where the debate will be held, which would require more than an hour, whereas in a car we could get to my parents' place, very close by. We end up at the debate. I have stage fright.

Paris, 9 December 2009

I'm in a room in the city, one that belongs to me, but which I don't occupy any more, a former studio perhaps? I have a vague notion there is a 'partnership'

between this room and where I live. I look at the objects left here—there is a toaster we could use. Actually, no, ours is better, newer.

All of this is connected to Seyss-Inquart but I don't know why. A vague feeling of anxiety.

Paris, 10 December 2009

I am being sought by the police. I'm afraid. I can't get too close to the bus station but I need to take one.

Later, an Italian film in an experimental art theatre. As I'm leaving, I'm in a vast, overgrown, wooded property; I tame a deer and I also see a stag with gorgeous antlers. I befriend a horse; I love wrapping my arms round its neck and pressing my cheek against its warm neck.

Paris, 11 December 2009

I was now covered with lice. I was shampooing my hair and trying to comb it myself, while doing a lot of other things. I was supposed to see some people, etc. I realized that if the lice weren't crushed, they would develop a rather pretty set of brown-and-beige wings, but they were still disgusting.

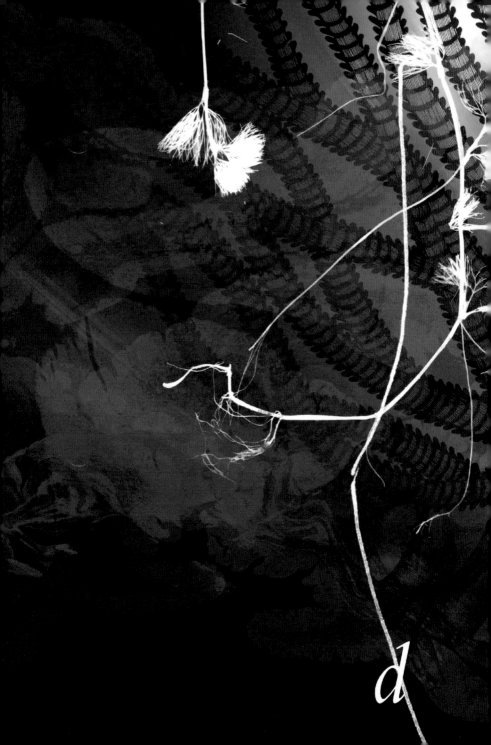

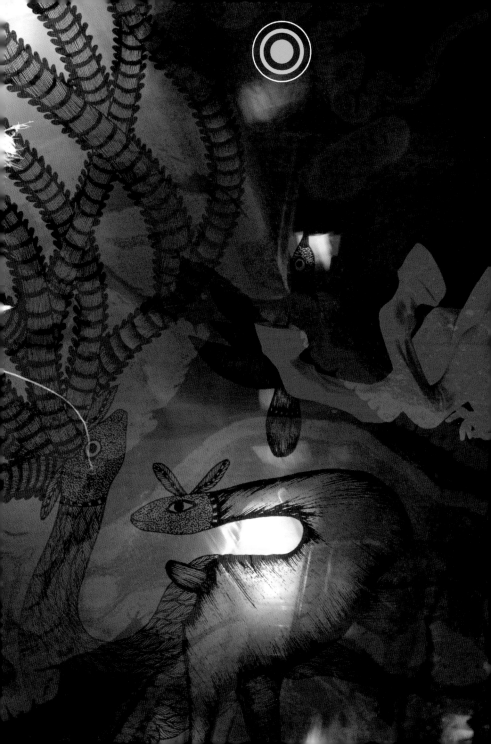

Paris, 14 December 2009

I arrive at the maternity ward, about to give birth, and then I black out. When I wake up I'm panicked—my stomach is flat again but I have no memory of the birth. And where is my son? I know his name is David, too, but it's not David, it's someone else.

No one is taking care of me, so I leave the hospital, completely confused. In the bus, I suddenly regain my senses—I have to feed that child! I get out of the bus and go back to the hospital, and this time, go up to the reception desk. An osteopath obstetrician hands me a purple smock: 'You're in labour? Put this on.'—'No, I've already given birth! I know you can't tell the difference (here, I burst into little-girl tears), but they didn't give me my son, I can't remember anything!' The osteopath is kind and takes care of everything.

Seville, 23 December 2009

V (again!) calls and wants me to come see him, up in Belleville. His motives seem completely impure, and I'm delighted. I thought I had put the kids to bed, but here they are with me, at least David, whom I have to

carry on the incline, in continual comings and goings. V calls me back, he's impatient. It's already 1.30 a.m.

Later, he and his boyfriend are running a hotel in the medina or, rather, in a casemate overlooking the city. I lose myself with Ariel in the elevator, we never reach the ground floor. I have long, shell-like breasts and I'm surprised I've never noticed them before. I feel like a different woman, and quite determined to take advantage of life in the daylight.

Seville, 24 December 2009

I am living in the medina, which is actually also the cité du Pressoir. I start hanging out at a local club which simultaneously includes a group of retirees, a stamp collector's club, a Yiddish class, etc. Paule and J-M are members, but I think I'm too young for it. For example, I still spend a lot of time with a stubborn little boy whom I have to teach how to climb a rope ladder. He's David, of course, even if he doesn't look like him (blond).

My brother and sister-in-law have bought a trailer for their car and put David and Marcel inside it. I protest: it is tiny, very close to the ground and to the car's exhaust pipes, has bad suspension. And no windows.

In super-impression (black and white) in the film (in colour, I remember distinctly that the trailer was blue), a scene of Holland during the war—the Nazis are ripping an entire plaza out of the ground, like the plaza de Santa Cruz here, people are standing on it and don't want to move. There is a priest in the middle wearing a blue surplus and gesticulating, explaining that if that's the way it is, very well, he will convert them elsewhere. He doesn't seem to understand that they're taking him away too.

Paris, 25 December 2009

I move into a residence for foreign students run by a pastor. I like him, even physically, but I wonder how long I'll be able to stand his preachiness.

Paris, 26 December 2009

I'm wearing my brown boots, which are thigh-high, but I had to take them off and set them next to the wall to go into the igloo. When I come out they aren't there any more, I should never have set them close to the trash cans! I spend the rest of the dream trying to track them down.

Paris, 28 December 2009

In a revolutionary theatre, I am having a lively debate with the Duke de Chambord who has become king again, a fact that I am one of the last not to acknowledge. I am very exposed in the courtroom, an ideal target, and I'm afraid he'll shoot me with his crossbow. I know the blows will not only be fatal but also very painful.

Later, things settle down, I'm going to be presented to him. A man in front of me, a loyal subject, starts singing a little song in front of the sovereign, that's part of the protocol. When my turn comes I imitate him as much as I can, *Ça ira*—it will do. Everyone is pleasantly surprised that I've been able to learn the protocol song by heart. After the presentation I indiscreetly say to someone, in a provocative tone: 'But you know, I can also sing *Il pleut, il pleut, bergère!*'

Another dream: We're at a ski resort but everything is going badly, the situation is actually very serious. My sister-in-law and I have covered a wall of the room with a greenish-black substance that looks like spinach. I'm rubbing at it with a sponge, the green is disappearing but the black seems indelible.

In Dreams

Paris, 29 December 2009

Dreams last night: I have to drive up to the high plateaus (Ardennes, Fagnes?) but the roads are flooded. I come upon a hole filled with water; incredibly bold, I drive onto the shoulder (on two wheels), the back end falls into the hole, but thanks to some thorn bushes or tree branches, it will be easy to get out if someone gives me a hand.

The Smadjas, another family, and mine have decided to move in together, in another building in the cité du Pressoir. Children are running all over, it's almost night, and there's always a lot of chaos. I wonder how I am going to stand not having my own office and not living on the ground floor any more. Do I have the right to scold other's children? How could we have jumped into this without discussing everything beforehand?

I have to get to Ventspils for a second stay, but the road between the bus station and the city is flooded. There is a ravine between the tree trunks, a ribbon of water that can be seen from above if you're in a helicopter. I'm finally able to get there on a narrow path on the shoulder meant for walkers. Reunions, etc., but I have

to leave right away. My boyfriend (?) makes a fuss not wanting to drive me back to the bus station, what a pain, I say to myself that if I leave that guy it won't be a big loss. He takes me, or I go on foot. Good riddance.

Paris, 30 December 2009

I'm an adult but nevertheless on a school trip. We're staying in an extraordinary place that looks like an old-fashioned swimming pool (with changing rooms on several floors, Edinburgh or Pontoise), an Italian theatre and a Roman villa. In fact, there is a swimming pool with ancient statues and mosaics on the bottom.

But the teenagers in the group are rowdy and very rough. Returning from an outing we find the passage-ways filled with broken glass. I pick up a broom to clean it up and I scold one of them, a handsome, insolent guy who looks like the lover in *Virgin Suicides* and who obviously couldn't care less, but is very cool. I go to the pool but it is also filled with debris. But apparently there is another one, modern, heated. I go there, wearing a swimsuit bottom. Through the windows I see it has started to snow. With a hand barely covering my naked breasts, I run round jumping, shouting 'Hooray! It's

snowing!' as if I were eight years old again, my body light and afraid of nothing.

Paris, 31 December 2009

I have to go to dreary Villeneuve-Saint-Georges, which in my dream is an ancient imperial city with palaces, vast properties enclosed by walls, etc.—a bit like what Potsdam is to Berlin, even geographically. In the southwest, then. But, I'm surprised to learn, it is also the city where the first cafe in France opened up, before the Procope. Diderot was believed to have written some of *La Religieuse* there. I have to go there for a literary gathering. But it's very complicated. Amid chaos and relative danger, I take the train which stops. I walk along the tracks. As I explain to Esther, I always have incredible adventures when I've tried to go into this area, Draveil, etc.

In the train car I meet a sister and brother, we chat politely. I like the brother. Arriving in Villeneuve, looking for the cafe in question, we jump from garden to garden over the walls that separate them, happy and carefree. The place looks like Saint-Germain-en-Laye.

I wake up like an impatient child. It's only six in the morning! Come on, I need to go back to sleep.

Paris, 2 January 2010

In a rather strange place, a sort of old palace turned into a hotel, I had a baby with someone, a woman. I settle the newborn gently onto a bed because I can't return before the evening. When I get back, they tell me that they heard it laugh (surprising for a newborn), cry a little too, but not much. I tell myself that this baby is a good thing because A's girlfriend will be able to take care of it too, and everyone will be happy.

In another dream, I show my father a photo of my maternal grandfather which intrigues me because above his (big) eyebrows you can see that he still has two little rectangular tufts of hair, like a toothbrush-shaped moustache. But, though I insist, my father doesn't want to see them, he says: 'No, you're wrong, those are eyebrows,' he refuses to look when I hold the photo up to him and point my finger at the place.

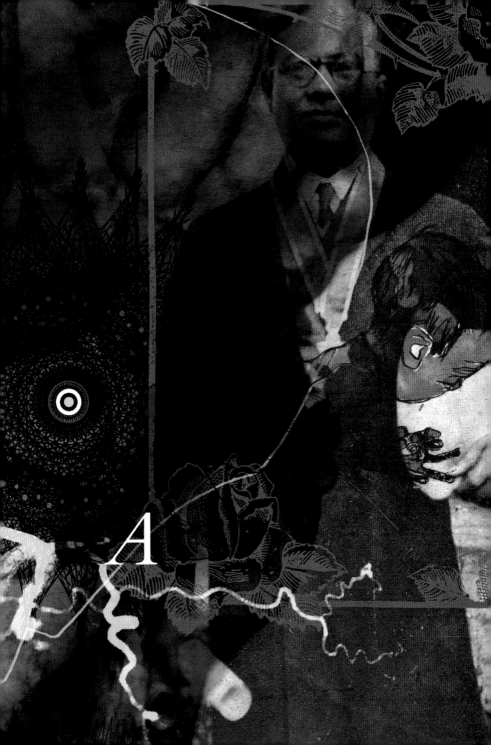

A

Paris, 5 January 2010

I am a jungle animal (but still a human being who can speak, etc.). We have to constantly run, hide, eat what we can, be on the alert so we're not caught and eaten. The worst part is that our predators are human beings too.

Paris, 10 January 2010

An arena, or a stage where an exit looks like an anus painted shocking pink. Obviously enflamed.

One might think of a baby but, in the dream, the name of the colour (*shocking* pink) clearly evoked a woman's anus.

Paris, 26 January 2010

I'm in a packed train, desperately trying to protect a tiny baby (Haitian?), not much larger than a doll, scarcely as big as my hand. It lives on practically nothing, a drop of water, a breadcrumb. When we arrive I'm dismayed to find that I wasn't able to save it—its eyes are closed, it is dead.

An obscure interlude with writers, academics, in a ridiculous atmosphere.

Then I'm with CD, the scene is very intimate, I even start telling her my latest dreams! I explain that to do this I need to lie down on my back and close my eyes, like at the psychoanalyst's. It's an obvious attempt at seduction. Anyway, I do what I said and lay down, my head on her lap. At that moment a maître d' opens the door of our private dining room and immediately shuts it, explaining to someone behind him: 'There are two women . . . ummm . . . busy working.'

Paris, 23 February 2010

During a guided tour, but which contains elements of danger (pursuits, risk of death), A gives me a boost so I can crawl through a skylight in a roof. I can just barely get through. While he is holding me (we are still married then), I describe what I see to him—a huge waterfall almost covering the other side of the grotto. It's the Weezie River, one of the four rivers of Hell, our guide explains, and he launches into the story. We decide not to try to have everyone go through the little

hole. It's better to listen to the story. Later, I am on the Brijuni Islands. I thoughtlessly drop a cigarette butt, which is forbidden. It's a long way back to the landing, if we've missed the little train.

Later still, I am in a courtyard in the 10th *arrondissement*. Miriam is there, and I ask her if she saw the triple rainbow the other day. Something dangerous appears in the sky, ridged, almost chocolate-coloured columns, it's a tornado, and we run in terror to find shelter. My new man, about whom I know nothing except that he is Pakistani and a taxi driver (we've only spent one night together), is very winded; I offer him an inhaler. Then I laugh at the situation with my friends: 'That's right, we don't know one another very well, we're still in the stages of asking one another: "By the way, are you asthmatic? Syphilitic?"'

Finally, on a beach, my new man (another) is giving a speech before the university commission to which I submitted an application to teach mathematics: 'Take her, please, she has waited long enough.' I have, in fact, been looking for a job for a long time, and he is speaking eloquently, but I say to myself that it would be better for me to defend my case myself.

Paris, 16 March 2010

There was a party at AK's; I arrived with the three children, which caused people to laugh, make fun of us—I just wanted to leave, even though the Métro trip to get there was long and complicated with the children. At that moment my father arrived and offered to drive us home. With him were M. Coscas, the pharmacist on rue Broca, and Bill Clinton, very jovial and smiling. It should have been a revenge on the people who were so mean to us. However, instead of being relieved, I woke up at that moment feeling very uneasy, drenched in sweat, terrified.

Paris, 2 April 2010

I'm walking up the rue des Couronnes after getting off the Métro. I am amazed to see the pavement so smooth and shiny, you can hardly even see the edge of the sidewalk, and I suddenly realize it is covered with a sheet of running water. So I take off my shoes and carry them (like in Ventspils on that stormy day, and with the same feeling of sensual intoxication, of pleasure in the middle of the street and in a public place). I arrive at a place that the water hasn't been able to reach because it's too

high, like Mount Ararat after the flood (that's not right, but that's the image that comes to me).

Later, I'm in Montreal and delighted to discover that there is a waterfront with ice-cream vendors, a sun-drenched wooden promenade. I decide to walk back to my hotel, even if it's five or six kilometres away. I'm ecstatic at the prospect of a walk outside in the sun.

Paris, 7 April 2010

We are threatened by a fire that is pursuing us in a maze of hallways. I'm very hot and very scared. A man with a pockmarked face is praying or is simply prostrated in the garden, because his children have died of meningitis. (He looks like the moujik with a bushy beard in *Anna Karenina*.) The fire advances on me and I close my eyes in terror, but it is transformed into a wind of cosmic particles that fall very softly, sounding like the pebbles that knock together in the sea when waves pull back. But I still awaken terrified since I'm so afraid of fire.

Paris, 12 May 2010

I'm in Ventspils, which is still part of the Soviet Union and where they speak Russian, with soldiers from the

Red Army, etc. The city is divided by the Iron Curtain—there is an East Ventspils and a West Ventspils. Over the walls and the barbed wire I see a little chateau that is being used as a Stalinist prison.

Paris, 30 May 2010

In Brussels. I'm watching the shooting of a film whose story is supposed to take place in Berlin. I note that, in fact, in some sections, the two cities look very much alike. Later, in Berlin where we have just moved, there's a big party with all my old friends. Suddenly, I discover that VB is G's current girlfriend. I announce to everyone that I can't stand it any more, I am shouting out of sadness and jealousy. Interlude: I've found a nanny for the children. But her mother smokes in the apartment. I tell her one of my sons is asthmatic, she says 'yes, yes' but doesn't put out her cigarette. She's a Gypsy with a very strong Berlin accent. G and I are finally and solemnly reunited after many months. He has assumed the appearance of a skinny, sickly cat, but I know it is he, and I hug him, I'm very happy. I put my arms round him and close my eyes, feeling intensely relaxed and at peace.

In Dreams

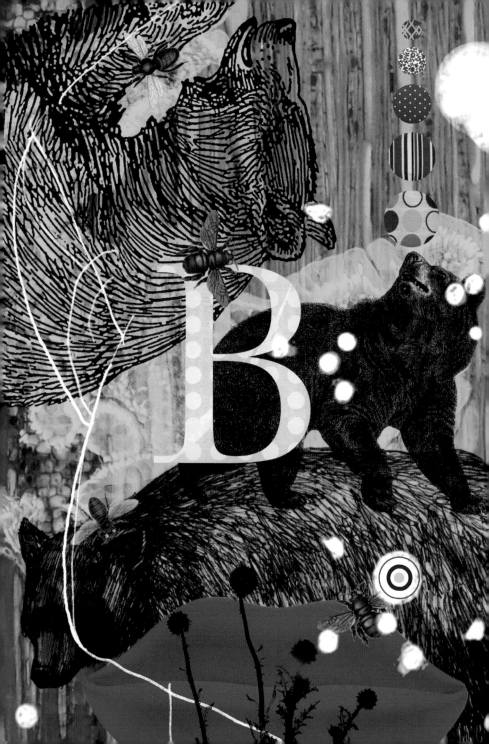

Mont-Noir, 6 July 2010

Dreamt of B. She was radiant, very kind. There was a red sofa, square, soft like a chocolate cake; she prevented me from cutting my fingers on its edges. I felt even more guilty towards her.

Mont-Noir, 7 July 2010

We received a young bear as a gift. I feel a bit lost, especially since a specialist explains to me—to have a bear in an apartment, you have to have 20 square metres more. But I feel better when I feed it, because it eats everything—salad, a slice of mozzarella . . . It even seems to like it. (Bär-lin?)

Another dream: I'm walking on the side of a steep dune.

Mont-Noir, 10 July 2010

In Prangeleux, which in my dream has become a huge wooden barn full of various, more or less useless objects —a little bouquet of dried flowers falling into dust on the sloping roof—an invasion of bees with brown fur. They disgust and frighten me but I take pity on them,

because I know they are migrating and on their way to their death.

They have landed inside the rooms and are swarming, hiding in holes—you can see only the black stingers sticking out, as if they were spiders or sea urchins. But since I know they are bees, I am not disgusted.

Berlin looks a lot like Brussels at least the neighbourhood where I've chosen to live. I am walking with insurgents, we must besiege the place. I go into a room that is a tiny cinema with decrepit red seats. VP and her sons are there and, in the row in front of her, M, who is voraciously kissing a young Polish woman who looks like MV. I think M is going too far—in front of his wife, no less!—and that VP lacks self-esteem. I sit behind them, not next to them, to show my disapproval. But the MV lookalike immediately comes and sits next to me and isn't even looking at M any more. She adores me, she kisses me, she even calls me 'mama'.

Mont-Noir, 14 July 2010

A street-party on rue des Maronites. Mireille says to me: 'In the end, there won't be anything on 10 May, no one

wants to.' I also speak with the mother of a student at the Collège Voltaire.

G has met someone, a young woman. For the time being, since they don't have anything better, they are still living with her parents, near the Château-d'eau Metro station.

An elective Greek class, Saturday morning. I go with the children, also interested. We have to take a bus that goes through the suburbs, it's in a little town north of Paris. Compiègne. We arrive late, which people find funny.

I go see some people I don't know, the parents of one of my children's friends? Their apartment is huge, strange, you go in through a little door that must have been a former entrance to a staircase. I don't really know what I'm doing there and they don't either. At the end of the hallways the very noisy bedrooms look right onto a highway entrance ramp. I mention that they would be better in the back of the apartment. They look at me, I have a feeling that I've said the wrong thing.

Mont-Noir, 18 July 2010

We are standing in the entrance to our troglodytic building that looks out onto the street. A is stationed on the other side of the lines, very far away, '*il est dans la Hollande*,' and he is shooting at us. He's not very worried about it, at such a distance it's not very likely that a bullet will reach us, but what about chance? I immediately envision a random bullet hitting David in his little body. I'm afraid, I'd like the children to go inside the building, that decaying and maze-like structure like the ones you see in cities in the south, Lyon, Modane. The other side of the building is calmer but it's a real mess. My paternal grandmother was still living here until recently. I remember the time when my maternal grandfather lived in the apartment, and I'm surprised once again at this confusion. Rue Émile Bouilliot.

Mont-Noir, 21 July 2010

Dreamt of G. In Paris, we were walking in a ritzy neighbourhood, in front of the Russian embassy where he had an important job. Turning round I noticed a narrow, forbidden door between two buildings. I was amused

when I realized that it was the end of the blocked passageway next to the German Historical Institute, the very place where I went to smoke cigarettes during my breaks. Without knowing it, and without seeing one another, our jobs were just a few feet apart!

Monbos, 1 August 2010

I was finally going to meet G, secretly, of course. Someone, perhaps P, perhaps one of our researcher colleagues, said out loud after I had left, thinking I didn't hear her: 'I think they are . . . We have to find out where Guetta is going (Guetta was G's name in my dream) and see if it's the same place.' To meet him, I went through a sort of mineral forest, in a vast subterranean world. I clung to columns of basalt, steep outcrops, it was very high up and I could have been killed but I wasn't afraid, because I knew that it was all a matter of point of view and that, if I looked differently, the vertical would become horizontal and vice versa.

Berlin, 22 August 2010

Last night, I dreamt that I was climbing a rope with my bare hands. Having gone up two-thirds of the way, I experienced a moment of exhaustion and despair, I saw the top of the cliff still far away, and below me the abyss, I couldn't go on, but I had to.

Dreamt also of G. He was standing in front of me, his back towards me, and I put my arms round his body and pressed my cheek against him, hugging him tightly. It felt so good.

And the night before (my first night here in Berlin), I had another dream, frightening but perhaps healthy— I had my period and all sorts of things came out with it, like a fish that was being gutted.

Berlin, 31 August 2010

Dreamt of G again. He was there, in the city where I lived, but he was constantly avoiding me, didn't have time, I never was able to see his face. It was simply a lingering pain.

Berlin, 12 September 2010

In a dark, deserted place, a sort of gloomy dune, I came upon the car that A had left there because he didn't need it any more. Open, ready to be taken. But, for a reason I no longer remember, my name was written on a label stuck on the windshield. I was reluctant to take this car which I might need (not to mention that I had a parking space in Paris), I even think that the license and registration were inside, the doors open, TAKE ME, but I couldn't make up my mind, a sort of horror was paralyzing me. I was horrified to see my name written on this abandoned vehicle that could be taken by the first person to pass by. It seemed like a death wish to me.

Berlin, 1 October 2010

I meet G in a bizarre place, a university dorm or a research institute, somewhere in a Baltic country. Several rather pretentious, hostile women look at me like I'm an intruder but I don't care, I know I have a place here because I love G, and anyway, these girls are not all that beautiful or intelligent. While waiting I file my

nails, I try not to be noticed too much, even if they obviously don't appreciate my presence.

And then, a catastrophe! I notice that I've spilt cooking oil on the rug. I try to clean it up (but half-heartedly, because they are annoying me). They look angrily at me. The oil doesn't go away, there is always more, there is also some in other places on the floor. I finally see that it is coming out of an enormous bottle, a sort of giant oxygen tank, tipped over on purpose, perhaps, to get me in trouble. I find this scheming ridiculous. As if they could discourage me with that!

Berlin, 8 October 2010

Dreamt that my sister was dead. She had died a long time ago but either I was speaking of it for the first time or I had just learnt of it, after a great delay.

Berlin, 9 October 2010

I was strolling in the suburbs of an industrial city in Ukraine, everything was chalk-white or grey, the sky was heavy and the air humid. I knew that the sea was somewhere nearby, probably misty and grey, also, but I

wanted and needed to see it. And I had left the children alone at home to go there. From a little platform that didn't look like anything, I went down some stairs and arrived in a huge school full of hallways, I asked some adults the way. They didn't understand me very well and asked me: 'Which teacher are you?' The misunderstanding cleared up, they showed me a door, which led me directly to a little boys' cloakroom. I finally found the exit and made my way to the sea, using my cellphone to try to call the children, who must have been getting worried since I had left at 3.30 p.m. and it was already almost 6.

At that moment I ran into them in the street, accompanied by my parents, and I woke up with a start thinking I had heard a bell.

Berlin, 11 October 2010

I dreamt that A had lost his father. I went to see him to give him my condolences, he turned towards me, his face was stricken, wet with tears, his eyes seemed less black.

Later, VG admitted to me and another girl from the *Livre des prefaces*, that she had never read Hugo or Balzac,

didn't know anything at all about nineteenth-century novels. I don't know why, to give her a taste for it, we tried to show her some connections between those authors and the Parisian suburbs—Sceaux (*Le Bal de Sceaux*, no doubt), Fontenay-aux-Roses (Huysmans? but isn't it rather L'Haÿ-les-Roses?), etc. . . .

Berlin, 18 October 2010

I notice that for months a large piece of stiff plastic has been embedded in my big toe, it has dislodged the nail, there is a gap between it and the skin. I pull out the piece of plastic, it doesn't look very good; when I push on the nail, the edge fills with blood. But I'm hopeful, it will heal now, the gap will scar up.

In a city that looks like ancient Greece and fascist Rome, composed entirely of stadiums, we are led from place to place like a band of deportees, anticlockwise, and I gradually realize that we are participating in a great tournament or in the Olympic Games. There is David who is supposed to compete in a tennis match and I'm worried—such a little boy, competing in front of millions of spectators? There is something barbaric in all that, it is cruel, like a gladiator show.

Dream Sunday morning: I absolutely have to go to Checkpoint Charlie, but I can't remember where the place is, and when I look on a map, it's not indicated anywhere. I wake up, and when I go back to sleep the dream resumes, for hours, it seems.

Berlin, 29 October 2010

I dreamt that Moka, the cat I used to have, understood human language, and not only French but English, too (I think). I said to her: 'I bet you can't get to the top of the stairs before me.' She looked at me maliciously and ran off.

In another dream, I was living with P and P in a sort of deserted medieval town, where the bells of the cathedral always rang at seven in the evening. It was vespers. At that moment, and only at that moment, in this town that we thought had been uninhabited for centuries, we saw old women coming out of their houses, scarves on their heads, moving slowly to attend the service.

We thought we were the only occupants of this decrepit property (a sort of Palladian house in ruins), but we discovered that a very chic antiques dealer was using

another section as her vacation home. One day they had a party, their table was decorated with inflammable objects and expensive linen, and the antiques dealer gave me a dirty look because in our part of the house I had created a big mess with candles and little bits of wood that caught fire. It was pretty but it was beginning to look like a fire was going to start.

During the meal, it seemed I had had an affair with P and P didn't know. I mischievously alluded to it in P's absence, not really trying to be bad, and P, imperturbable (and profoundly humiliating) declared without looking at me that he didn't regret a thing, but that for him it had only been an 'exchange of fluids'.

I could only burst out laughing and go up into the yard above, perhaps to look for the children, perhaps also looking for more mischief.

In fact, it was afterwards that I spoke to my cat.

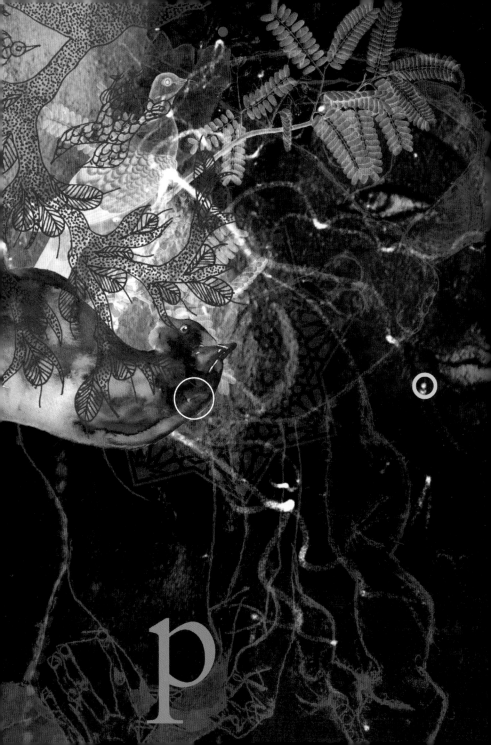

Berlin, 4 November 2010

I ran into J by chance in a neighbourhood with long streets, houses enclosed by fences, bridges. After pursuing me, he finally convinced me to have sex with him. It didn't happen in a bedroom but in a public place, or at least outside; I had the *geographic feeling* that it was in a corner of a quadrilateral two sides of which were the Boulevard Raspail and the Boulevard Montparnasse, even if it didn't look like that at all.

J was fatter and more vulgar than ever, the act was rather sordid and, at the moment he penetrated me, I realized that he had covered his penis with a white cream with a strong medicinal odour, which I assumed was a contraceptive or (absolute boorishness) something to prevent STDs, because one never knows.

It immediately burnt me, I pushed him away and looked at what was written on the jar: it was a poison for garden birds, a toxic and irritating product made in Yugoslavia before the fall of the Wall.

I screamed that he was crazy, I spat on the ground—I also had it in my mouth—I spat and spat that white horror and then I went off towards the elevated Métro,

completely disgusted. At the station—which now looked like Barbès, near the place where G and B once lived, and which in my dream coincided with the Prenzlauer Berg station where G began to pout darkly on Friday evening because I suggested we should go home (it was past midnight and I was tired)—I pondered whether I might not in fact take advantage of the two days off to treat myself to a little trip to Croatia where I would not run into J since he was in Paris. And then I decided not to, telling myself that he might have the same idea.

I was going home and was never going to see him again and that thought made me very happy.

Berlin, 18 November 2010

I'm in my apartment in Berlin, which is, however, larger than in reality, square, with a different design: there are double doors everywhere, like in the Rigiblick hotel in Zurich. My mother is there and is looking for a book on the bookshelf, she chooses a children's book that I don't really like, an old paperback that came from their

house. She is very nervous, she is turning her flight tickets over and over, I ask her why. 'Do I really have to tell you?' 'Of course, tell me, I don't understand.' 'Come on, you really don't know?' 'No, I really don't.' 'Well, I went back to work.' It takes me a moment to grasp the importance of what she has told me. She has returned to work whereas she has officially retired, she risks being sanctioned by the governing council. I argue that it would not be very serious, since she was no longer working. But there is worse, she explains: she was ordered not to leave the country during the investigation, and she came here. The children's book is an alibi, she has to justify her presence in Berlin by claiming she had important reading to do.

And then my father arrives through the same door. He is looking for a plastic duck, a bath toy, I don't understand why he needs it, let alone for whom, it can't be for my children, they're too old. 'So you don't know for whom?' 'No, I assure you.' 'Well, you should have an idea!' 'No, I don't, you have to explain it to me.' 'Really, you don't know?!' My obtuseness exasperates him. Fortunately, I wake up before he gets really angry.

Berlin, 24 November 2010

The city (which one? maybe Lvov) contains a separate place, a sort of parallel world accessible through only one entrance. It feels sort of like Disneyland but doesn't look anything like it, rather it resembles the scenery of *The Enchanted Flute* and *Bastien et Bastienne*. And real things, fraught with meaning, happen here, it's not a marginal world of pure illusion.

I couldn't say what's happening to me. But afterwards, at the end of a journey that takes me into Western Europe and seems to have been as long as one of Voltaire's or Casanova's, or the Prince de Ligne's, my mount, or our draught animal—which isn't a horse but a more slender animal with fragile limbs, like the cows you see in India, or maybe a zebu—takes a bad fall at a full gallop. She (for I vaguely know it's a 'she') is lying on her side, trembling, suffering, but she doesn't protest when I try to take care of her. On the contrary, she seems to understand and delicately places her rear hoof in my hand as if to tell me: 'Heal me.' But I can't see anything, the shoe and the tender skin at the hollow show no wounds, nor is there a thorn; the scene is

repeated several times although I still don't understand any better and while examining the hoof I hurt the animal without being able to heal it, and each time she bites me I feel the imprint of her jaws on my hand, the shape of each tooth, but it is only the jaw of a ruminant which doesn't hurt. She bites me to make me understand something, but what? I'm dismayed at my impotence. The animal will perhaps die of its wounds or it will be put down, like a racehorse that can no longer walk.

I finally arrive in France and I immediately go to rue d'Ulm where I hadn't been for many years. There are several people I want to see again, especially EL, EG and H. I look for their classroom but I'm afraid I won't recognize them after such a long time. Also, it's the break between classes and the hallways are filled with nervous and excited students and I finally learn why: the classrooms are going to be flooded with two to three metres of water, because the next class is a swimming class. In my time, everyone knew how to swim well by the time they were adults but, during my long absence, things have changed, regressed. Schoolchildren,

especially girls, aren't taught how to swim any more, for reasons of decency.

Speaking of water, the water in my bottle is warm and stale, which isn't surprising after such a journey. At the restaurant in the station, with AS and maybe Malika, I say to the waitress at the counter, holding out my bottle: 'You can use this to water the plants,' (I've become very ecologically minded in Germany) 'the three of us will have some very cold mineral water.' The waitress stares at me, her eyes widening, and everyone starts laughing: without realizing it, I've said that in German. I repeat it in French, exaggerating my Parisian accent so the waitress won't think I'm a tourist. I, who am in fact at *home*!

Berlin, 25 November 2010

A huge lion is advancing over the plain. It is so big that the tropical forest under it seems to be merely a green velvet carpet. I watch in terror as some parallelepipedal objects topple over, I'm afraid they are apartment buildings, crowded apartment towers, but then I see they are books, standing upright, shuddering as the monster approaches. Men and women the same height as the

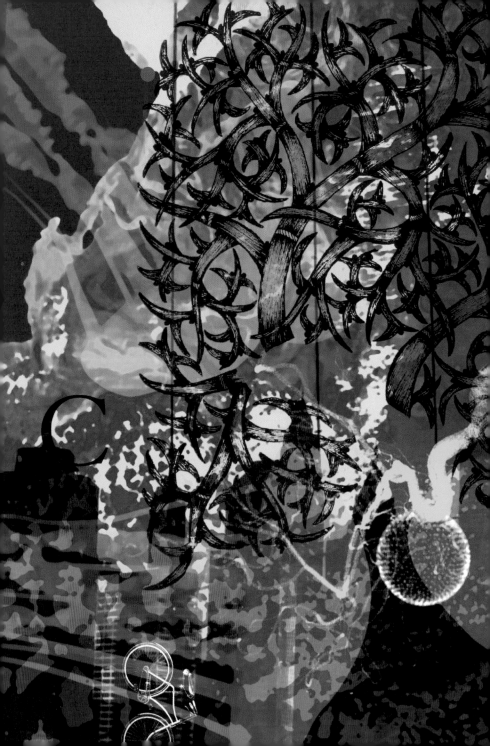

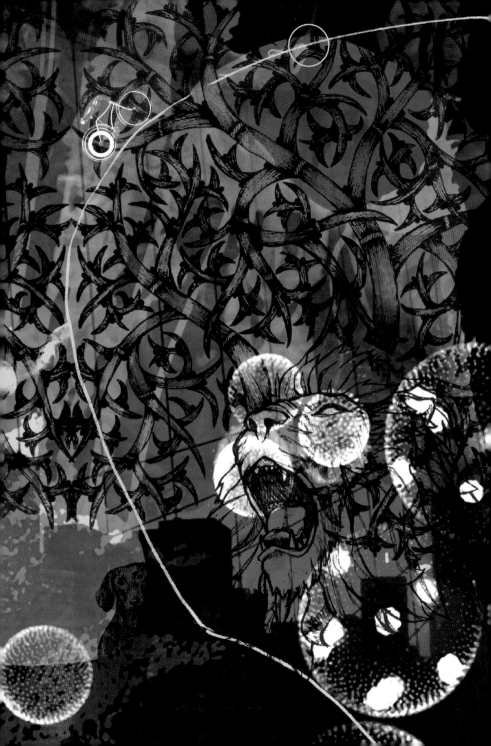

books run between them, I don't have time to wonder
if the books are very tall or the people very short, the
entire scene appears to have fallen prey to a confusion
of scale and I must quickly find shelter.

In the city, the evacuation or passive defense operations
have begun, people are jumping on their bikes, or on
their scooters; the film (because this is a film) empha-
sizes that they all have a wheeled vehicle to get round.
Is this a humanity that has forgotten how to walk and
is being punished for it? The only exception is a young
boy who decides to stand upside down, his two arms
leaning on the leashes of his dog who is pulling him
along very quickly, here too, all the laws of physics are
disturbed and it is incomprehensible but beautiful to
see, it's likely this young boy will be one of the main
characters in this disaster film and he will survive.

And me? I don't have a bike or a scooter, I'm barefoot
and wearing a light nylon blouse even though it's freez-
ing, but I have to keep going, we can already hear the
lion's footsteps entering the first suburbs. Below the
parapet that I climb over, the sea is roiling.

Later, in an apartment, the children are disturbing me while I am trying to work, especially O who insists that I join their game. He has built an object that he calls an artificial uterus and he will be very disappointed if I don't play the role of the mother. I have work to do but I agree, grudgingly, because he's our guest. Much later, I realize he is not with us any more and I remember that I myself had suggested he live with us a few days a week, and that it was going pretty well, it wasn't a lot more work, but I am incapable of saying when the last time was that we'd seen him here. What negligence! And what will I say to his mother when she comes to get him!

A person I know is talking to a disturbing man who refuses to acknowledge that he is a Russian gangster, he claims simply to be the manager of the LSD chain (Love Sex Dreams, Potsdamer Straβe, dark-blue and shocking-pink sign, I often see it when I go by in the bus). But what is he thinking? His denial doesn't fool anyone! The road ahead goes to Poland, I see only a few cars; I would have thought the roads would have been more crowded on this day of exodus.

In Dreams

Berlin, 26 November 2010

After a walk in Mitte, I want to take the Monbijou-brücke to the S-Bahn to reach Oranienburger Straße which, in my dream, is on the other side. But the water is high, the bridge is submerged even if the parapets can still be seen, and the branch of the river is as wide as the canal that separates Giudecca from Venice. We stop to watch the spectacle—it's beautiful but darkly melancholic, like Venice in the winter, in fact. Suddenly the water starts to rise to our level, a grey, muddy water. The children are laughing, our feet are wet, it's not very serious but I have the feeling that it could quickly become dangerous, like at Mont-Saint-Michel when the tide rises.

We take another route to get to Friedrichstraße. It's a strange neighbourhood with narrow, steep streets, it looks like Lisbon, and it's still raining and night has fallen. In a little street that rises straight up, I am amazed to see a stroller in the middle of the road (as steep as the stairs in Odessa). If the water starts flowing, the stroller will be carried away. What's more, as I get closer, I discover that it contains a sleeping baby and a little

child, it's a double stroller. I ask the little girl what they're doing there, if I can take them to their parents? She's obviously afraid that I'm going to kidnap them, she doesn't want to move and I finally understand why—she lives right here, on the ground floor of the building, I ring the bell.

I enter right into a family gathering, there are several adults and other children, I explain: it's night, they shouldn't leave their children outside, especially with the threat of a flood, etc. The parents or the hosts answer me very coldly, as if I were making a mountain out of a molehill and was sticking my nose in what was none of my business. Disgusted by this nonchalance combined with ingratitude, I want to leave but I can't find the boys anywhere—they've gone to play with the children in the family, great! Here I am, wishing to make a quick and dignified exit, now I'm wandering round the apartment yelling 'Davi-i-i-d!' in a voice that is sharper than necessary. I must say that I really want to sleep, to the point that I feel I'm about to cry, and the mother of the family, rather bourgeois and perfectly in control of herself, watches me going to such trouble and

In Dreams

appears to think I'm ridiculous. Unless the boys have gone back out into the street before Esther and me?

A blank—I am in the same place with the same woman but we're chatting almost amicably. She is asking me very precise questions about my divorce, the apartment on rue des Maronites—how does she know all that? I finally realize she's a lawyer, but I wonder with some concern how she was able to access the file. To deflect the conversation, I pick up a little book sitting on a tray whose cover is held together with clothespins: Does someone in the house by chance do bookbinding? 'Oh, no,' she replies, 'but everyone is more or less in publishing, a writer, screenwriter . . .' That's interesting! I tell myself that I might have been lucky to happen upon them after all. But the lawyer returns to my divorce: it's a pity that I'm French, she says, in German law there is the clause specifying 28,000 marks per child (what is she talking about?! But at least she doesn't know everything about me, since she thinks I'm French), she chatters on faster and faster, I follow less and less. '. . . That's what Zaïd did with her children.' 'Excuse me, who's Zaïd?' She becomes vehement, aggressive, it's too easy

to pretend not to know people you're acquainted with, I should be ashamed! I rack my brains: is she by chance talking about Zahia? No, Zahia doesn't have any children—the lawyer is holding me hostage and is now talking about the *Bilamban*, if I've heard right, 'But I don't know what you're talking about—is it the title of a book?' It seems that yes, it is a very well-known book that might even have won the Goncourt Prize and I have never heard of the author, who turns out to be one of her friends. Now she is in a complete rage, I don't understand a thing, she's crazy, that's obvious—now she's making anti-Semitic remarks or, on the contrary, accuses me of being an anti-Semite. I have to get out of here. A madwoman.

In the street, her husband catches up with us, *he* is very calm, serious, with a bit of a Brussels accent. He hasn't come to excuse his wife but to offer to drive us to the S-Bahn. I refuse, however, I don't want anything more to do with these people. He insists and I drag the children down the stairs pretending not to hear. Later, we are walking towards Friedrichstraße, the walk is long but luckily the neighbourhood has become familiar, we

are indeed in Berlin and I am happy finally to breathe
fresh air. There are a lot of people, lights, Christmas dec-
orations.

Berlin, 27 November 2010

I'm in love with a very elusive man, a blond. We make
love but when I start to caress his shoulders or take him
in my arms, he gets up, acting hurt and shocked, and
leaves. He makes it very clear, he doesn't want such
familiarity between us.

I am Dr Freud, I temporarily inhabit his person and,
from where I am, I have access to his thoughts and feel-
ings. I discover he is very misogynous and I am rather
amused that he has no idea what female pleasure is.

I'm with my mother at the theatre or at a concert in
Brussels, the seats are normal stuffed seats but are also
toilets. So I pee there but I'm not very relaxed, trying
to look nonchalant. The problem is that we are also sup-
posed to go that evening to have dinner at a German
friend's house in Thuringia, at a cultural centre that was
once the house of a famous writer or philosopher. A
pity that I haven't brought my camera to take photos

of the interior. But in any event, it seems less and less possible that we will be there at a reasonable hour for dinner: it is after nine o'clock and we are still in the outskirts of Brussels, not even on the highway.

But I know it's there, in Germany, that I met the blond man, during a school trip that Justus was also on.

Berlin, 28 November 2010

I'm living in a cave that opens onto the Mediterranean, geographically it should face the Balearic Islands, but I know that it's Corsica over there, somewhere in the distance, without being able to see it. And the dishes are made of turquoise-blue pottery, the colour of the jug I brought back from my trip to Corsica with PG's parents when I was five. The top of the table is the same blue, it's beautiful, this entirely turquoise table, in the golden light of the setting sun.

Y is there too, I'm happy to see him even if I don't really understand what he wants with me. He tells me about an industrialist from the nineteenth century who had become famous by publishing his memoirs which has stayed a bestseller for all this time, I finally remember

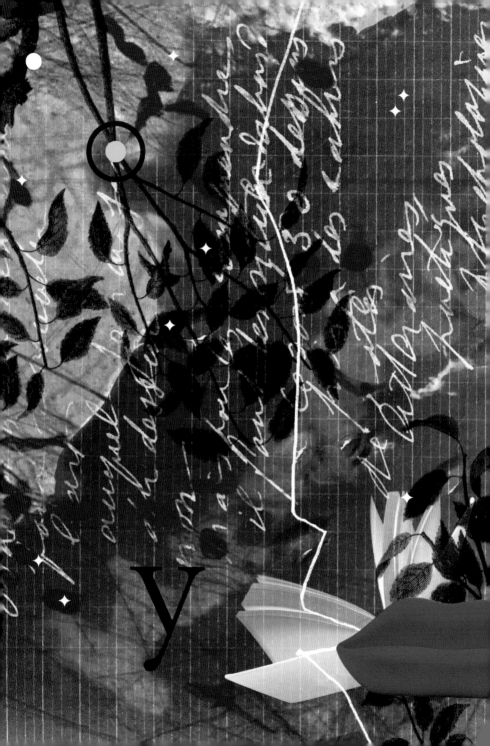

that very well-known book, a copy of which I must have seen at someone's home, maybe at my parents'. But why is Y talking to me about all that? Is he intending to publish his own memoirs or suggesting that I publish mine? He seems to be emphasizing that the life of that industrialist was of no interest and that it was only a means to make a lot of money. I'm a bit surprised, this is not like him.

Berlin, 30 November 2010
A complex story involving several people, perhaps participants in a colloquium (on urbanism): they all seem very serious, even uptight, but I know that in their minds it's Woodstock, there are erotic waves in the air. And then, JR, looking rather ridiculous in his loden-green Tyrolian overcoat, kisses me passionately, without ostentation but in front of the others, including JL. This happens in a place that must be the place du Pantheon on the Sainte-Geneviève side but which looks more like the edge of a forest. Uh-oh, the big bad wolf isn't far away! I have a hard time not laughing but I go along, remembering the student I once was when I would really have liked JR to kiss me.

Later, I'm in a car with the same men, we are looking
for the exit for a neighbourhood church, Saint-Médard
or Saint-Étienne-du-Mont, but in my dream it's a tiny
chapel built inside another ancient building. Our driver
thinks he's found the entrance and heads into a tunnel,
which is extremely narrow and winding, not surprising
in this very old section of Paris. He's wrong, we're going
down into the *parking des Patriarches*, he has to back up!
Yikes! Another car has already come up behind us. Even
though I'm in a car and with others, these narrow tun-
nels where you can't pass anyone or turn round make
me claustrophobic. Let's get out of here fast.

Berlin, 8 December 2010
My parents are showing me a little video they took on
one of their cellphones. I see myself next to my mother,
going into a rather chic brasserie, it must be in Paris.
Close up of our feet: I notice I'm wearing a tall, white
boot, rather vulgar, and a big ski sock that goes up to
my knee. In the video, it is also the moment when I
notice it, I'm seen leaning over in embarrassment and
quickly pulling off the ski sock, laughing, but I'm not
very happy that there is a record of that ridiculous

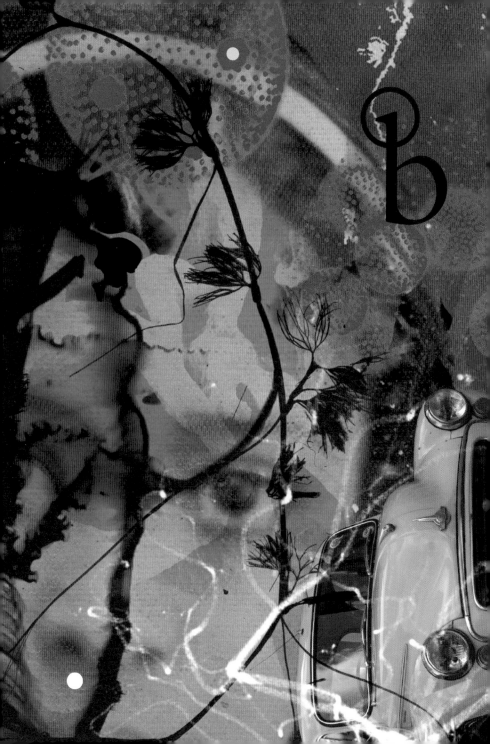

moment that I thought had gone by unnoticed. In addition, I don't understand how my parents were able to take that video. Firstly, my mother is in the film with me. And then the angle—it's looking down—indicates that the video was taken not from street but from the second floor, or higher, and we don't know anyone who lives in this sort of rue de la Paix neighbourhood. It must be footage from a surveillance camera, in fact, but how did it get on my parents' cellphone?

Berlin, 9 December 2010
I take a bus to go to the Lycée Français in Brussels early in the morning, the bus is packed with teenagers and students who are going to their classes. In front of me there is a young man, tall, who is talking loudly with his friends above my shoulder. As often happens in a crowded bus, our bodies almost touch, then they touch completely and I realize that we've done it on purpose. What's more, apparently by accident, the young man moves his hands on the metal bars, so now I really am in his arms. To show him that I've understood and agree, I put my hands under his jacket, round his body, and I place my cheek against him.

However, we act as if nothing is going on, I push the button as usual because I have to get off soon, he continues to talk with his friends. I miss the Dieweg stop but it's not a problem because the bus (which I've never taken) then turns right, which will get me closer to the lycée. At the bottom of the hill, I really have to get off this time, we don't know one another's names or telephone numbers, in fact, I really never even saw his face, I only know that he has black hair, of course. He must think that I take this bus every morning, whereas this was unusual, I don't live in Brussels. I explain that to everyone as I'm getting off but not loud enough, and too late, I hear the bus taking off and my lover still laughing with his friends, on the other side of the window.

The field between the road and the lycée is white with snow, I walk across it thinking of that sad story. In any case, that boy was a university or high-school student, and how old am I? To tell the truth, I don't know any more, because I am myself going to the lycée, my satchel on my shoulder. I go in through the kitchen, where there are some cooks from the Antilles wearing

In Dreams

blue smocks and light green caps, like in a hospital or a food factory. I know the students are not allowed to smoke but, after all, I'm of age. I want to ask one of the cooks for a cigarette, since they look so nice, one of them must certainly smoke, and we adults, we adult women, we understand one another—I've just found a lover and have lost him forever, I need a cigarette. I'll smoke it in the field, not inside, that's a promise, but I have to hurry, the bell is going to ring in five minutes.

Berlin, 26 December 2010
I've enrolled in the university again and am looking for the entrance, which isn't obvious, hidden among all sorts of offices and shops. It should be the place du Pantheon but it doesn't look like it at all, there isn't the Pantheon. I lean on a railing to watch a street scene below, along with other onlookers. The man next to me is PF. He doesn't remember my name but is smiling broadly. He introduces me to the girl with him (whose waist he was hugging only a moment earlier, I saw) as 'Nadine, my assistant'. He's lying, that's clear, but I find him rather seductive, more than before.

Berlin, 27 December 2010

I'm on the street, there must be snow because the ground is white and without wanting to, I find myself mixed up in a hostage situation. Someone I know very well, but can't say who it is beyond being one of the hostage-takers, points to the ground at a sewer cover or an opening to the subway and tells me authoritatively: 'They are in there. You're going to film them all, one by one, before we kill them.' We risk being killed ourselves if we don't obey. I tell myself that the only thing to do is ignore his order completely and disappear, leave the city and never come back, it is the only way to escape this mafia. But what will become of the hostages?

Brussels, 1 January 2011

I'm a few days pregnant, even though there is no man in my life, it's a mystery and it most likely won't be simple, practically speaking. AS is pregnant too but is crying as she tells me—I can't understand why she's so upset. Jealousy, because once again I'm pregnant before her? A hormonal disorder? I try to console her but I have

to leave for Brussels. Someone drives me to the airport,
my father or some other man, the way there is very
complicated (we're in the suburbs of Bordeaux). Sud-
denly, on the road I see in horror that the arrows are
pointed towards us—we've headed out on the highway
in the wrong direction.

To avoid a collision, instead of asking my driver to park
on the emergency strip (he doesn't really seem to know
what he's doing), I go back a bit in time to start over
on the right foot—My trip to Brussels is connected to
an important story of a strike, I remember now.

I finally arrive at a small airport that could be Tempel-
hof, it is 8.20 a.m. I breathe a sigh of relief, everything
is fine, the plane takes off at 8.25. But I have forgotten
to check in, security checks, etc. . . . ! A subconscious
decision; I obviously didn't want to go to Brussels. But,
in fact, the flight has been cancelled or delayed, a chap-
erone on a school trip tells me. I might be able to leave
after all and no one will know anything about my lapse.

But there is Ken whom I promised to drive to his par-
ents' house. And there is a man who is participating in
the Bordeaux colloquium. He is brilliant, has a rather

handsome face but, something awful, he has hardly any legs—vestigial, without feet, shrivelled matchsticks of red flesh. Apparently, he has been paralyzed since childhood and has never walked. It's a pity, he's an attractive man all the same . . .